D1698034

# LIVING IN STYLE
# BERLIN

**Edited by Stephanie von Pfuel**
**Texts by Judith Jenner**

teNeues

# Contents

| | |
|---|---|
| Introduction | 4 |
| Artful Colors | 10 |
| Black Beauty | 18 |
| Futuristic Living | 28 |
| Private Luxury | 34 |
| Ethnic Treasures | 44 |
| Timeless Elegance | 56 |
| Music Meets Movement | 62 |
| Urban Oasis | 72 |
| Collector's Paradise | 86 |
| Mirror, Mirror on the Wall | 98 |
| Bohemian Chic | 106 |
| Loft in Kreuzberg | 114 |
| Back in the Days | 122 |
| Rooms with a View | 132 |
| Stylish Art Lovers | 142 |
| Private Gallery | 154 |
| Color Me Softly | 164 |
| Joy & Jewelry | 174 |
| Modern Glamour | 186 |
| Classical Modernity | 192 |
| Courageous Living | 202 |
| Index | 214 |
| Biographies | 215 |
| Credits & Imprint | 216 |

# Introduction
## Judith Jenner

Arguably, Berlin has undergone more changes in recent decades than any other European city. After German reunification, many of the old buildings lining the streets in the eastern boroughs were in poor condition and still relied on wood-burning stoves for heat. But even the West was different than it is today. Quite a few neighborhoods in what is now Berlin's city center were fairly run-down.

Since then, the city has been transformed. Districts such as Prenzlauer Berg and Mitte have been spruced up. Along with Kreuzberg, they are now highly coveted residential areas. A complete office and business quarter has sprung up around Potsdamer Platz, and new government buildings were constructed in preparation for the German parliament's move to Berlin in the summer of 1999. Many business enterprises have also relocated to the capital, especially media companies.

Thanks to its vibrant art and cultural scene, Berlin draws visitors from all around the world. Part of the city's appeal is the fact that it provides ideal places for people to build their dream homes. Over and over again, Berlin attracts attention with unusual construction projects, many of which seamlessly combine the old with the new.

This book showcases the contrasts that make Berlin the city it is today. This metropolis has it all—from a modern villa in Grunewald to the residential tower of a magnificent building dating back to the Socialist era and even a converted brewery. And let's not forget Berlin's classic old buildings constructed during Germany's 19th-century Gründerzeit period. These apartments feature stucco moldings and double doors, herringbone parquet floors, and "Berliner Zimmer," traditional rooms that connect two sections of a space. The images on the following pages show the finished transformation of these spaces—whether as luxurious retreats, reception halls, private museums, or stylish stage sets—each displaying a piece of the personalities behind them.

# Einleitung
## Judith Jenner

Kaum eine Stadt in Europa hat sich in den vergangenen Jahrzehnten so verändert wie Berlin. Nach der Wende waren viele Straßenzüge im Ostteil von baufälligen Altbauten geprägt, oft gab es noch Ofenheizung. Doch auch der Westen sah anders aus. Etliche Gegenden, die heute das Zentrum der Stadt ausmachen, lagen verhältnismäßig brach.

Das hat sich grundlegend geändert. Bezirke wie Prenzlauer Berg und Mitte haben sich herausgeputzt und sind ebenso wie Kreuzberg zu begehrten Wohnlagen geworden. Rund um den Potsdamer Platz entstand ein gesamtes Büro- und Geschäftsviertel neu. Hinzu kamen die Regierungsbauten für den Umzug des Deutschen Bundestages im Sommer 1999. Auch viele Unternehmen, besonders aus der Medienbranche, zog es seitdem nach Berlin.

Durch seine lebendige Kunst- und Kreativszene wurde Berlin zum Magnet für ein internationales Publikum. Besonders reizvoll an der Stadt ist, dass sie Raum bietet für individuelle Wohnträume. Immer wieder macht Berlin mit außergewöhnlichen Bauprojekten auf sich aufmerksam. Oft verbinden sie Alt und Neu auf wirkungsvolle Weise miteinander.

In diesem Bildband sind die Gegensätze vertreten, die Berlin ausmachen: Von der modernen Villa in Grunewald über den bewohnten Turm eines sozialistischen Prachtbaus bis hin zur ehemaligen Brauerei ist alles vertreten. Nicht fehlen dürfen natürlich die klassischen Berliner Altbauwohnungen aus der Gründerzeit. Sie zeichnen sich durch Stuck und Flügeltüren, durch Fischgrätparkett und das „Berliner Zimmer" aus. Wie diese Wohnungen zu luxuriösen Rückzugsorten, Repräsentationsräumen, privaten Museen oder zum extravaganten Bühnenbild werden – und was sie über ihre Bewohner erzählen –, all das zeigt dieses Buch in ausgewählten Bildern.

# Introduction
## Judith Jenner

Aucune autre ville en Europe ne s'est autant métamorphosée ces dernières décennies que Berlin. Après le « Tournant », de nombreuses rues de la partie est étaient bordées d'anciennes bâtisses délabrées, encore équipées de poêles de chauffage. La partie ouest était également bien différente. Bon nombre de quartiers, qui constituent aujourd'hui le centre de la ville, étaient relativement délaissés de toute occupation.

Tout a changé de manière considérable. Les arrondissements comme Prenzlauer Berg et Mitte se sont mis sur le trente et un et sont devenus des lieux de domicile très appréciés. Les alentours de la Potsdamer Platz ont vu s'ériger un nouveau quartier de bureaux et boutiques, auquel sont venus s'ajouter les bâtiments du gouvernement, lorsqu'en été 1999 le Bundestag a déménagé à Berlin. Depuis, beaucoup d'entreprises, du secteur des médias en particulier, sont venues s'installer à Berlin.

Le dynamisme de la scène artistique et créative de Berlin attire un public international. Sa particularité réside dans une diversité de lieux qui offre à chacun l'occasion de construire la maison de ses rêves. Berlin attire en permanence l'attention avec ses projets de construction extraordinaires. L'ancien est souvent relié au moderne pour un résultat des plus étonnants.

Cet ouvrage illustre les contrastes qui révèlent le Berlin d'aujourd'hui : de la villa moderne dans le Grunewald à l'ancienne brasserie en passant par la tour habitée d'une ancienne bâtisse somptueuse de l'époque du socialisme, il y en a pour tous les goûts. N'oublions pas non plus les anciens appartements classiques du Gründerzeit dont Berlin regorge, qui se distinguent par leurs enduits en stuc, leurs portes à deux battants, leurs parquets en point de Hongrie et la « chambre berlinoise ». Ce livre présente en images comment ces appartements se sont transformés en refuges luxueux, salles de représentation, musées privés ou en décors de théâtre extravagants – et ce qu'ils révèlent de leurs habitants.

# Artful Colors
## Charlottenburg

THE KORNFELD GALLERY on Fasanenstraße exhibits contemporary art. In a collaborative effort with the Gisbert Pöppler interior design firm, the proprietor furnished an apartment above the gallery, where he hangs his private collection. He meets with collectors here and also holds private receptions. "Unlike the white cube on the ground floor, the apartment is all about color," the gallery owner explains. "The color schemes are coordinated with the art." The kitchen is a brilliant red and the living room a warm shade of gray, while lilac dominates the bedroom. New stucco decorates part of the ceiling, and the exposed-concrete fireplace was made to order. The back of the apartment opens onto a balcony, where stairs lead down into a sculpture garden.

DIE GALERIE KORNFELD in der Fasanenstraße zeigt zeitgenössische Kunst. Ein Stockwerk darüber hat der Galerist zusammen mit dem Inneneinrichtungsbüro von Gisbert Pöppler eine Wohnung eingerichtet, in der seine Private Collection hängt. Hier gibt er private Empfänge oder zieht sich für Gespräche mit Sammlern zurück. „Im Gegensatz zum White Cube im Erdgeschoss spielen in der Wohnung Farben eine entscheidende Rolle", erklärt der Galerist. „Sie sind exakt auf die Kunst abgestimmt." So leuchtet die Küche in kräftigem Rot, das Wohnzimmer ist in einem warmen Grauton gehalten, und im Schlafzimmer dominiert Lila. Für die Decken wurde teilweise neuer Stuck angefertigt. Auch der Kamin aus Sichtbeton ist eine Sonderanfertigung. Im hinteren Teil öffnet sich die Wohnung zum Balkon mit Treppe in den Skulpturengarten.

LA GALERIE KORNFELD, située dans la Fasanenstraße, est un repère d'art contemporain. L'étage supérieur, aménagé par le galeriste avec le soutien du cabinet d'architecture de Gisbert Pöppler, abrite un appartement dans lequel sa collection privée est exposée. Il y organise des réceptions privées ou y accueille des collectionneurs. « Contrastant avec le monochrome du White Cube du rez-de-chaussée, les couleurs dominent l'appartement », déclare le galeriste. « Elles s'accordent parfaitement avec les œuvres artistiques exposées. » Ainsi, la cuisine rayonne d'un rouge écarlate, le salon est revêtu de tonalités chaudes de gris et la chambre est dominée par le lilas. Les plafonds ont été partiellement garnis de nouveaux stucs. La cheminée en bétonbrut a été coulée sur mesure. Du balcon, situé à l'arrière de l'appartement, un escalier mène au jardin des sculptures.

12 | Artful Colors

*The owner and the interior designer came up with an ingenious color concept for the domed rooms to set off the private art collection.*

*Für die kuppelartigen Räume haben sich Bauherr und Innenarchitekt ein ausgeklügeltes Farbkonzept überlegt, das die Kunst aus der Private Collection zur Geltung kommen lässt.*

*Le maître des lieux et l'architecte d'intérieur ont élaboré une palette sophistiquée pour mettre en valeur les œuvres de la collection privée qui sont exposées sous des voûtes.*

*The Kornfeld Gallery exhibits contemporary art in the basement.*

*Die Galerie Kornfeld zeigt im Souterrain zeitgenössische Kunst.*

*Au sous-sol, la galerie Kornfeld abrite des œuvres d'art contemporain.*

Artful Colors | 17

# Black Beauty
## Mitte

SYLVESTER KOZIOLEK, a Polish-born set and interior designer, has always had a thing for the color black. "Back in the Renaissance, artists painted portraits on a black background because it made the faces stand out better," he explains. So it's entirely logical that the color black also dominates his apartment in an old building: the walls, the floor, even the kitchen tiles. As a result, this color scheme provides an effective backdrop for the handpicked furniture, from the anthroposophical Rudolf Steiner desk to the Murano glass lamps to the Cubist credenza. Koziolek purchased some pieces at auction and built others himself—his bed, for example. "I was inspired by a Memphis design," he admits with a smile.

SCHWARZ HAT ES dem polnischstämmigen Set- und Interiordesigner Sylvester Koziolek angetan. „Schon in der Renaissance wurden Porträts vor schwarzem Hintergrund gemalt, weil die Gesichter auf diese Weise besser zur Geltung kommen", erklärt er. Und so ist es nur konsequent, dass auch seine Altbauwohnung inzwischen vollkommen schwarz ist: die Wände, der Boden, ja sogar die Kacheln in der Küche. Das hat den Effekt, dass die handverlesenen Möbel wirkungsvoll in Szene gesetzt werden. Sei es der anthroposophische Schreibtisch von Rudolf Steiner, die Lampen aus Muranoglas oder das kubistische Buffet. Viele Stücke hat Koziolek bei Versteigerungen erstanden, manche aber auch selbst gebaut, zum Beispiel sein Bett. „Dabei habe ich mich von einem Memphis-Entwurf inspirieren lassen", gibt er lächelnd zu.

LE NOIR EST la couleur de prédilection de Sylvester Koziolek, designer d'intérieur et scénographe d'origine polonaise. « Les portraits de la Renaissance étaient déjà peints sur des fonds noirs afin de mieux faire ressortir les visages », déclare-t-il. Que de plus logique donc que son appartement soit complètement revêtu de noir : les murs, le sol et même le carrelage de la cuisine. Ce qui met particulièrement en valeur les meubles sélectionnés avec soin, qu'il s'agisse du secrétaire anthroposophique de Rudolf Steiner, des lampes en verre Murano ou du buffet de style cubique. Koziolek a acquis la plupart de ces œuvres lors de ventes aux enchères. Certaines sont ses propres créations, par exemple son lit. « Je me suis inspiré ici d'un croquis de Memphis », reconnaît-il avec entrain.

*Sylvester Koziolek paired a wall cabinet by French architect and designer, Charlotte Perriand, with the black tiles in his kitchen.*

*Zu den schwarzen Kacheln in seiner Küche kombinierte Sylvester Koziolek einen Hängeschrank von der französischen Architektin und Designerin Charlotte Perriand.*

*Sylvester Koziolek a combiné une armoire suspendue de l'architecte et designer française Charlotte Perriand aux carreaux noirs de sa cuisine.*

Black Beauty | 23

*In the set designer's apartment, classic pieces such as the daybed by Jean Prouvé contrast with Bauhaus lamps. A Rudolf Steiner desk stands by the wall.*

*Klassiker wie das Daybed von Jean Prouvé treffen in der Wohnung des Set-Designers auf Bauhaus-Leuchten. An der Wand steht ein Schreibtisch von Rudolf Steiner.*

*Des classiques comme le daybed de Jean Prouvé et des lampes Bauhaus décorent l'appartement du créateur de scènes de théâtre. Le long du mur se trouve un bureau de Rudolf Steiner.*

*The homeowner bought much of his furniture at auctions. His favorite place in the apartment is his bed. He had it built nearly 30 years ago according to his own design.*

*Viele seiner Möbel hat der Hausherr auf Auktionen ersteigert. Sein Bett ist für ihn der schönste Ort in der Wohnung. Er ließ es vor fast 30 Jahren nach einem eigenen Entwurf bauen.*

*Le maître des lieux a acquis de nombreux meubles dans des ventes aux enchères. Il considère son lit comme la plus belle pièce de son appartement, qu'il a fait construire il y a presque 30 ans, d'après ses propres plans.*

# Futuristic Living
## Grunewald

WITH THE EXCEPTION of Villa M by HSH Architekten, modern architecture is a rarity on the outskirts of Berlin. The house is situated in a colony of villas that was built in the Grunewald Forest in 1889. The villa's surroundings are responsible for its striking shape. While a conventional building would cast the entire property in shadow, this house takes full advantage of the movement of the sun. The ground floor is built around an atrium, which has a glass ceiling and is open to the pool. A sweeping staircase leads to the second floor, which accommodates guest rooms, a movie theater, a music room, and a study. It also provides access to the terrace. The third floor, where the bedrooms are located, extends over the terrace and protects it from rain. Thanks to state-of-the-art building services, music and movies can be controlled from a central point and broadcast to all the rooms.

MODERNE ARCHITEKTUR IST am Stadtrand von Berlin rar. Eine Ausnahme bildet die Villa M von HSH Architekten. Sie liegt inmitten einer Villenkolonie aus dem Jahr 1889 im Forst Grunewald. Ihre markante Form ist der Lage des Grundstücks geschuldet: Während ein konventionelles Gebäude das gesamte Gelände in den Schatten stellen würde, nutzt dieses Haus den Sonnenverlauf optimal aus. Das Zentrum des Erdgeschosses bildet das Atrium mit seinem Glasdach. Es lässt sich zum Pool hin öffnen. Über die geschwungene Treppe gelangt man in den ersten Stock, wo Gästezimmer, Kino, Musizier- und Arbeitszimmer sowie der Zugang zur Terrasse sind. Sie wird vom zweiten Stockwerk mit den Schlafzimmern überragt und ist so regengeschützt. Dank moderner Haustechnik lassen sich Musik und Filme zentral steuern und in allen Räumen abspielen.

L'ARCHITECTURE MODERNE EST rare dans la périphérie de Berlin. L'exception à la règle n'est autre la Villa M de HSH Architekten. Elle est située au milieu d'une colonie de villas de 1889 dans la forêt du Grunewald. Elle doit sa forme marquante à la situation du terrain : alors qu'un immeuble conventionnel plongerait l'ensemble du domaine dans l'ombre, cette villa profite au maximum du cycle solaire. L'atrium avec son toit en verre constitue le centre du rez-de-chaussée, qui donne directement sur la piscine. On atteint le premier étage par un escalier arcué où sont situées les chambres d'amis, le cinéma, la salle de musique, le bureau et l'accès à la terrasse que surplombent les chambres à coucher du deuxième étage, la protégeant ainsi de la pluie. L'installation technique moderne de la maison permet une commande centralisée de la musique et des films, et de leur diffusion dans toutes les pièces.

*The LED lights make the shower seem to float in space. An audio and video server plays music and movies throughout the entire house.*

*Durch die LED-Beleuchtung wirkt die Dusche schwebend. Ein Audio- und Videoserver versorgt das ganze Haus mit Filmen und Musik.*

*L'illumination LED confère à la douche une impression de flottement. Un serveur audio et vidéo se charge de diffuser des films et de la musique dans toute la maison.*

*The home's unusual shape is due to its orientation toward the position of the sun.
The roof takes on a dynamic shape when viewed together with the garden.*

*Die ungewöhnliche Form des Hauses rührt daher, dass es sich am Sonnenstand orientiert.
Eine optische Verbindung zum Garten stellt die dynamische Form des Daches her.*

*La forme inhabituelle de la maison vient du fait qu'elle s'oriente sur la position du soleil.
La forme dynamique du toit établit une connexion optique avec le jardin.*

# Private Luxury
## Mitte

IN MATTERS OF style, Patrick Hellmann is a real pro. The designer lives with his family in a penthouse in the Mitte district, complete with a large rooftop terrace and a view of Gendarmenmarkt. The interior design was inspired by the 1930s Art Deco style, updated to suit contemporary tastes. Hellmann and his wife found many of their original pieces of Macassar ebony furniture in Parisian antique shops. They had some of the chairs re-upholstered in luxurious new fabrics and lined the apartment's sloping walls with elegant velvet in the fireplace room and cashmere in the living area. Certain pieces, such as the bed, were made to order according to Hellmann's own designs.

PATRICK HELLMANN IST ein Profi, wenn es um guten Stil geht. Der Designer lebt mit seiner Familie in einem Penthouse mit großer Dachterrasse und Blick über den Gendarmenmarkt. Inspiriert ist die Einrichtung vom Art-déco-Stil der 30er Jahre, der allerdings in die heutige Zeit übersetzt wurde. Viele der Originalmöbel aus Makassar-Holz fanden Hellmann und seine Frau in Pariser Antiquitätengeschäften. Zum Teil ließen sie Sitzmöbel mit neuen, hochwertigen Stoffen beziehen. Auch die Wandschrägen wurden im Ess- und Kaminzimmer mit edlem Samt und im Wohnbereich mit Kaschmir bespannt. Einzelne Stücke wie das Bett sind Spezialanfertigungen nach Plänen des Hausherrn.

PATRICK HELLMANN EST passé maître dans l'art du bon goût. Le designer et sa famille vivent dans un attique du quartier Mitte s'ouvrant sur un toit-terrasse avec vue sur le Gendarmenmarkt. La décoration de l'appartement reflète le style Art déco des années 30 avec une touche de modernité. Les nombreux meubles originaux en ébène de Macassar, achetés par Hellmann et sa femme, proviennent de boutiques d'antiquités parisiennes. Certains sièges ont été recouverts de nouveaux tissus luxurieux. Du velours recouvre les sous-pentes de la salle à manger et de la chambre avec cheminée, et le cachemire domine celles du salon. Certains meubles comme le lit en cuir ont été spécialement construits sur mesure d'après les plans du maître de maison.

Luxurious materials such as black enamel and light-colored cashmere on the walls dominate the living room.

Im Wohnzimmer dominieren edle Materialien wie schwarzer Lack und heller Kaschmir an den Wänden.

Des matériaux luxurieux, comme le laqué noir et le cachemire clair, dominent les murs du salon.

Private Luxury | 39

*The owners furnished the apartment gradually over time. Fabric on the penthouse's sloping walls adds an elegant finish to the décor.*

*Die Einrichtung der Wohnung ist mit den Bewohnern gewachsen. Stoffbezüge veredeln die Schrägen des Penthouse.*

*L'aménagement de l'appartement est fidèle au style de ses occupants. Des tissus recouvrent les sous-pentes de l'attique.*

The bedroom pays homage to the 1930s. A leather bed designed by the homeowner forms the room's focal point. Patrick Hellmann also designed the folding screen.

Das Schlafzimmer ist eine Hommage an die 30er Jahre. Mittelpunkt des Raumes ist das eigens angefertigte Lederbett. Den Paravent hat Patrick Hellmann designt.

La chambre à coucher rend hommage au style des années 30. Le lit en cuir, fait sur mesure, constitue la pièce maîtresse de la chambre. Le paravent a été conçu par Patrick Hellmann.

# Ethnic Treasures
## Friedrichshain

CLAUS SENDLINGER, CEO of Design Hotels, makes his home in a space where hops and malt used to be stored. The former brewery has exposed walls that create an appealing industrial ambience. "They provide a rough contrast to the hand-planed oak floorboards. We whitewashed the exposed masonry on the old walls and plastered the new ones," says Armin Fischer of the Dreimeta design studio. His plans included space for the treasures that Sendlinger collected on his travels—sculptures, bowls, and other souvenirs that add a personal touch to the apartment. The first floor contains the kitchen, dining room, and a guest room. Upstairs are the adults' and children's bedrooms, the bathroom with a steam room, and a gym. The best view is from the rooftop terrace, which is partially glassed-in and has a Jacuzzi.

WO SICH HEUTE die Wohnung von Claus Sendlinger befindet, CEO von Design Hotels, lagerten früher Hopfen und Malz. Industriecharme geht von den freigelegten Wänden der ehemaligen Brauerei aus. „Sie bilden einen rauen Kontrast zu den handgehobelten Eichendielen. Bei den alten Wänden hat man nur das freigelegte Mauerwerk getüncht, bei den neuen einen Lehmputz aufgebracht", sagt Armin Fischer vom Designbüro Dreimeta. Er plante auch Raum für Sendlingers Fundstücke ein, die er von seinen Reisen mitgebracht hat: Skulpturen, Schalen und andere Souvenirs geben der Wohnung eine persönliche Note. Auf der ersten Ebene befinden sich Küche, Ess- und Gästezimmer. Darüber sind Schlaf- und Kinderzimmer, das Bad mit Dampfsauna und der Fitnessraum untergebracht. Den besten Blick bietet die teilweise verglaste Dachterrasse mit Jacuzzi.

LE LIEU QUI abrite l'appartement de Claus Sendlinger, CEO de Design Hotels, accueillait à l'époque des stocks de houblon et de malt. Les murs dégagés de l'ancienne brasserie confèrent à l'endroit un charme industriel. « Ils contrastent avec les planches de chêne manuellement poncées. Les murs dégagés ont été blanchis ; les nouveaux murs ont été enduits d'argile », affirme Armin Fischer du bureau Dreimeta. Il a également prévu de l'espace pour accueillir les œuvres de Sendlinger, trésors ramenés de ses voyages : sculptures, coupes et autres souvenirs apportent à l'ensemble une touche personnelle. Le premier étage abrite la cuisine, la salle à manger et la chambre des invités. Les chambres à coucher, dont celle des enfants, la salle de bains avec hammam et la salle de fitness sont situées à l'étage supérieur. La meilleure vue est accessible de la terrasse sur le toit, aménagée d'un Jacuzzi.

*Even the bathroom has design elements from far-off lands. A raffia mat from Bali covers the door. A steam room, fitness room, and walk-in closet lie behind the rust-brown wall.*

*Auch im Bad stehen weitgereiste Stücke. Die Tür ist mit einem Bastgewebe aus Bali bespannt. Hinter der rostigen Wand befinden sich Dampfsauna, Fitnessraum und begehbarer Kleiderschrank.*

*La salle de bains est également garnie de pièces provenant de contrées lointaines. La porte est recouverte d'un tissu de rabane de Bali. Derrière le mur oxydé se situent le hammam, la salle de sport et le dressing.*

Ethnic Treasures | 51

The apartment is located in a brewery that is under historic preservation. The living room has a skylight and plenty of space for treasures that the globetrotting homeowner has collected on his travels.

*Die Wohnung liegt in einer denkmalgeschützten Brauerei. Im Wohnzimmer mit Oberlicht ist viel Platz für Fundstücke des reisefreudigen Hausherren.*

*L'appartement est situé dans une ancienne brasserie classée monument historique. Le salon équipé d'un vasistas abrite nombreux trésors que le maître des lieux a ramenés de ses voyages.*

54 | Ethnic Treasures

# Timeless Elegance
## Charlottenburg

FRANK STÜVE RUNS the Villa Harteneck showroom in Grunewald. This magnificent property is where he sells furniture from companies such as Minotti and Promemoria, along with select accessories, to Berlin's elite. His private residence is a classic Berlin apartment in an old building near the Ku'damm that features stucco moldings, parquet floors, and double doors. Linear '60s-style furniture that Stüve boldly pairs with opulent chandeliers creates a counterbalance. The homeowner is fond of contrasts. He places shiny surfaces next to matte ones, modern objects next to antiques, until his apartment resembles a skillfully arranged flower bouquet. Which is no coincidence. In fact, Frank Stüve is a florist, not an interior designer. The pleasure he derives from combining pretty things spills over into his work.

IM GRUNEWALD BETREIBT Frank Stüve den Showroom Villa Harteneck. In dem prunkvollen Anwesen präsentiert er der Berliner Stil-Elite Möbel von Firmen wie Minotti oder Promemoria sowie handverlesene Accessoires. Sein privates Domizil liegt in unmittelbarer Ku'damm-Nähe: eine klassische Berliner Altbauwohnung mit Stuck, Parkett und Flügeltüren. Als Gegenpol dazu fungieren geradlinige Möbel im Stil der 60er Jahre, die Stüve mutig zu üppigen Lüstern kombiniert. Überhaupt mag der Hausherr Kontraste. Er setzt glänzende neben matte Oberflächen, moderne neben antike Objekte, sodass seine Wohnung schließlich wie ein gekonnt zusammengestellter Blumenstrauß wirkt. Das ist kein Zufall: Eigentlich ist Frank Stüve nicht etwa Innenarchitekt, sondern gelernter Florist. Die Freude am Kombinieren schöner Dinge begleitet ihn bis heute bei seiner Arbeit.

FRANK STÜVE TIENT le salon d'exposition de la Villa Harteneck située dans le quartier Grunewald. Il présente dans cet édifice de prestige des meubles haut de gamme comme Minotti ou Promemoria ainsi que des accessoires sélectionnés avec soin. Son domicile privé se situe à proximité du « Ku'damm »: un ancien appartement classique berlinois composé de stuc, parquet et de portes à deux battants. Contrastant avec l'ensemble, on y retrouve des meubles aux formes rectilignes des années 60 que Stüve combine courageusement avec des lustres opulents. Le maître des lieux est un grand adepte du contraste. Il favorise le mariage de surfaces brillantes et opaques, de meubles modernes et antiques afin de transformer son appartement en un bouquet de fleurs parfaitement composé. Ceci n'est point étonnant, puisque Frank Stüve est avant tout fleuriste de profession, et non architecte d'intérieur. La satisfaction de combiner divers genres a toujours fait partie intégrante de son travail.

*A round settee dominates the entrance to Frank Stüve's apartment. The vases are from Asia.*

*Den Eingangsbereich von Frank Stüves Wohnung dominiert ein rundes Canapé. Die Vasen stammen aus Asien.*

*Le canapé rond domine le hall d'entrée de l'appartement de Frank Stüve. Les vases proviennent d'Asie.*

*The homeowner lovingly restored classic elements such as the ornate wall decorations, which he paired with sofas and chairs from Promemoria.*

*Klassische Elemente wie die prunkvollen Wandornamente ließ der Hausherr liebevoll restaurieren. Dazu kombinierte er Sessel und Sofas von Promemoria.*

*Le maître des lieux a fait restaurer avec beaucoup d'amour les fastueux ornements muraux auxquels il a combiné des fauteuils et divans de Promemoria.*

# Music Meets Movement
## Charlottenburg

YOU WOULD NEVER guess that this apartment, which is owned by a music manager and a trapeze artist, was once a rundown bed-and-breakfast. Until the architect, Thomas Kröger, created spacious rooms by removing walls. The couple later purchased a separate apartment with its own entrance, where the lady of the house set up a gym for practicing her aerial numbers and teaching Pilates. The wall paneling in the entrance area has an interlocking circle motif that reflects her work. The master of the house turned the library into his own personal domain. "We built special shelving made of light-weight metal that prevents the weight of the books from placing too great a strain on the building's static equilibrium," he explains. Like the rest of the apartment, most of the library's furniture comes from the Hans-Peter Jochum Gallery.

NICHTS ERINNERT DARAN, dass die Wohnung eines Musikmanagers und einer Trapezkünstlerin einst eine abgewirtschaftete Pension war. Denn Architekt Thomas Kröger ließ Wände entfernen und schaffte so großzügige Räume. In einer weiteren, später dazugekauften Wohnung mit separatem Eingang befindet sich der Übungsraum der Hausherrin: Hier trainiert sie ihre Luftnummern und unterrichtet Pilates. Die Wandtäfelung im Eingangsbereich nimmt mit ineinandergreifenden Kreisen Bezug auf ihre Arbeit. Das Reich des Hausherren ist die Bibliothek. „Eine spezielle Regalkonstruktion aus Leichtmetall stellt sicher, dass die Statik des Hauses durch das Gewicht der Bücher nicht zu sehr strapaziert wird", erläutert er. Eingerichtet ist sie – wie auch der Rest des Appartements – vorwiegend mit Möbeln aus der Galerie von Hans-Peter Jochum.

QUI CROIRAIT QUE cet appartement, où logent aujourd'hui un imprésario et d'une trapéziste, abritait jadis un hôtel dégradé ? L'architecte, Thomas Kröger, y a fait disparaître certains murs pour obtenir des pièces spacieuses. L'appartement attenant avec une entrée séparée, acheté dans un deuxième temps, abrite la salle d'entrainement de la maitresse des lieux, dans laquelle elle perfectionne ses numéros de trapèze et enseigne la méthode Pilates. Les lambris de bois de l'entrée aux motifs circulaires entrelacés font référence à son métier. L'antre du maitre des lieux n'est autre que la bibliothèque. Il souligne que « l'étagère spéciale aux parois de métal léger s'assure que la statique du bâtiment ne soit aucunement influencée par le poids des livres ». Celle-ci est principalement décorée, tout comme le reste de l'appartement, de meubles provenant de la galerie de Hans-Peter Jochum.

64 | Music Meets Movement

*The indirect lighting from the oval in the ceiling bathes the library in soft light.*
*The bookshelves were made to order, designed by architect Thomas Kröger.*

*Ein indirekt beleuchtetes Oval an der Decke taucht die Bibliothek in ein sanftes Licht.*
*Das Regal ist eine Sonderanfertigung nach den Plänen von Architekt Thomas Kröger.*

*La forme ovale au plafond est indirectement illuminée et répand sur la bibliothèque une douce lumière. L'étagère a été construite sur mesure d'après les plans de l'architecte Thomas Kröger.*

*The décor in the relatively small bathrooms leaves the impression of black-and-white pixels.*

*Die verhältnismäßig kleinen Bäder sind in einer schwarz-weißen Pixel-Optik gehalten.*

*Les salles de bains, proportionnellement petites, sont décorées de pixels noirs et blancs.*

66 | Music Meets Movement

*A wavy pattern decorates the red closets on the way to the bedroom. Inspired by Brazilian architects Lúcio Costa and Oscar Niemeyer, the design alludes to the lady of the house's native culture.*

*Auf dem Weg ins Schlafzimmer ziert ein Wellenmuster die roten Einbauschränke. Es ist von den brasilianischen Architekten Lúcio Costa und Oscar Niemeyer inspiriert und spielt auf die Herkunft der Hausherrin an.*

*Sur le chemin vers la chambre à coucher, un motif de vague orne les armoires encastrées rouges ; chef d'œuvre inspiré des architectes brésiliens Lúcio Costa et Oscar Niemeyer et clin d'œil aux origines de la maîtresse de maison.*

*In the gym, the lady of the house practices her aerial numbers and teaches Pilates.*

*Im Gymnastikraum übt die Dame des Hauses ihre Trapeznummern und gibt Pilates-Unterricht.*

*La maîtresse de maison répète ses numéros de trapèze dans la salle de gymnastique et y donne des cours de Pilates.*

# Urban Oasis
## Kreuzberg

THE OWNERS OF this home delight in their rooftop garden, which occupies nearly 3,200 square feet of space in the heart of Kreuzberg. In addition to their fabulous apartment on the top floor of an old building, they also have a spacious garden paradise with green turf, lush vegetation, and a Jacuzzi. It extends from the front building, across the wing and over the roof of the house at the back of the property. The apartment below has an open plan with very few walls. Even the bedroom is separated from the living and guest quarters by nothing more than a short flight of stairs. Behind it lies the wellness area and pool. The homeowners bought nearly all the furnishings—from the chandelier to the designer kitchen and even the marble staircase—at online auctions. They collected many sculptures on their travels, as well as the hand-made Bangkirai parquet floor from Southeast Asia.

ÜBER FAST 300 Quadratmeter Dachgarten mitten in Kreuzberg können sich die Eigentümer freuen. Denn in der obersten Etage eines Altbaus besitzen sie nicht nur eine fantastische Wohnung, sondern auch ein großzügiges Gartenidyll mit Rollrasen, üppigen Pflanzen und Jacuzzi. Es zieht sich vom Vorderhaus über den Seitenflügel bis über das Dach des Hinterhauses. Die Wohnung darunter kommt fast ohne Wände aus. Sogar das Schlafzimmer ist vom Wohn- und Gästebereich nur durch eine kleine Treppe getrennt. Dahinter befindet sich der Wellnessbereich mit Pool. Fast das gesamte Mobiliar – vom Kronleuchter über die Architektenküche bis hin zur Marmortreppe – haben die Bauherren im Internet ersteigert. Viele Skulpturen, aber auch das handgefertigte, südostasiatische Bangkirai-Parkett, brachten sie von Reisen mit.

LES PROPRIÉTAIRES PEUVENT se réjouir de la toiture-jardin d'environ 300 mètres carrés de surface. A l'étage supérieur d'une ancienne bâtisse, ils disposent d'un appartement magnifique, mais également d'un généreux jardin où le gazon, la végétation luxuriante et le Jacuzzi confèrent à l'endroit une atmosphère idyllique. Celui-ci s'étend de l'avant de la bâtisse jusqu'au toit de l'arrière-bâtiment, en surplombant l'aile latérale. L'appartement en-dessous ne compte que quelques murs porteurs. La chambre à coucher est séparée du salon et de la salle des invités uniquement par un petit escalier. A l'arrière se situent la salle de bien-être et la piscine. L'ensemble du mobilier – des lustres à l'escalier de marbre, en passant par la cuisine architecturale – provient presque essentiellement de ventes aux enchères sur internet. Les nombreuses sculptures, ainsi que le parquet en Bangkirai, fait main, proviennent de voyages.

*This loft in Kreuzberg is all about contrasts: showy ornamentation and bare brick walls, exotic sculptures and rectilinear design.*

*In der Kreuzberger Dachgeschosswohnung begegnen sich Gegensätze: Prunk trifft auf nackte Backsteinwände, exotische Skulpturen auf geradliniges Design.*

*L'appartement sous les toits dans le quartier Kreuzberg est dominé par les contrastes : le faste détonne sur des murs de briques nus, un design rectiligne accentue des sculptures exotiques.*

Urban Oasis | 77

*The couple purchased many of their furnishings from online auctions. A steel girder had to be provided for the marble staircase leading to the rooftop terrace.*

*Viele Einrichtungsstücke hat das Ehepaar im Internet ersteigert. Für die Marmortreppe, die auf die Dachterrasse führt, musste ein Stahlträger eingezogen werden.*

*Le couple a acquis nombreuses pièces de décoration dans des ventes aux enchères sur internet. Une poutrelle métallique a dû être incorporée à l'escalier de marbre qui mène à la terrasse.*

Urban Oasis | 79

Urban Oasis | 81

*The large bathroom, an indoor pool, and a guest bathroom with an illuminated tub and sink turn the apartment into a wellness oasis.*

*Das große Badezimmer, der Indoor-Pool und das Gästebad mit beleuchteter Wanne und Waschbecken machen die Wohnung zu einer Wellness-Oase.*

*La grande salle de bains, la piscine intérieure et la salle de bains des invités avec baignoire et évier illuminés confèrent à l'appartement une atmosphère d'oasis de bien-être.*

The rooftop garden extends over the front, side, and rear sections of this old building, offering a panoramic view of the city.

Die bepflanzte Dachterrasse erstreckt sich über das Vorderhaus, den Seitenflügel und das Hinterhaus des Altbaus. Von hier hat man einen weiten Blick über die Stadt.

La terrasse sur toit couverte de plantes, qui s'étend de la partie avant à la partie arrière de l'ancien édifice en passant par l'aile latérale, offre une vue panoramique époustouflante sur la ville.

# Collector's Paradise
## Charlottenburg

DESIGNER FRANK LEDER chose an apartment in an old building in Charlottenburg as his living quarters and workspace. The abundant ornamental elements on the ceilings and wood-burning stoves—typical for this neighborhood—date back to Germany's 19th-century Gründerzeit. "After living in a loft for many years, I wanted to have walls where I could hang photos, posters, and pictures," he says. The owner decorated the apartment with furniture, artworks, and curios that he collected on his travels, purchased at flea markets, bought from online auctions, came across serendipitously, or received as gifts. Frank Leder constantly changes and rearranges his collection, an activity that comes quite naturally to him. It inspires him in the work he does as a designer of clothing and limited-edition furniture. One thing is for certain: "My living environment and my work are a marvelous influence on each other."

DESIGNER FRANK LEDER hat sich zum Leben und Arbeiten eine Altbauwohnung in Charlottenburg gesucht. Hier fallen die Verzierungen der Gründerzeit an Decken und Öfen besonders üppig aus. „Nachdem ich jahrelang in einem Loft gelebt hatte, wollte ich wieder Wände haben, an denen ich Fotos, Poster und Bilder aufhängen kann", sagt er. Die Einrichtung ist über Jahre gewachsen. Möbel, Kunst und Kuriositäten hat er von Reisen mitgebracht, auf Flohmärkten gekauft, im Internet ersteigert, gefunden oder geschenkt bekommen. Die Sammlung und ihre Inszenierung verändern sich ständig – für Frank Leder ein ganz natürlicher Prozess, der ihn auch bei seiner Arbeit, dem Entwerfen von Mode und limitierten Möbelkollektionen, inspiriert. Für ihn steht fest: „Meine Wohnumgebung und meine Arbeit beeinflussen sich auf wunderbare Weise gegenseitig."

LE DESIGNER, FRANK LEDER, cherchait comme lieu de vie et de travail un appartement ancien dans le quartier du Charlottenburg. L'opulence des décorations des plafonds et des poêles datant du Gründerzeit attirent ici particulièrement l'attention. « Après avoir vécu pendant des années dans un loft, j'aspirais à avoir de nouveau des murs auxquels je pouvais accrocher des photos, posters et tableaux », déclare-t-il. La décoration est composée de divers objets acquis au cours de sa vie ; des meubles, des objets d'art et curiosités achetés lors de ses voyages, sur des brocantes, sur internet ou qu'il a simplement trouvés ou qu'on lui a offerts. Frank Leder modifie sa collection d'objets insolites et leur mise en scène en permanence – ce qui n'est pas inhabituel, car source d'inspiration pour cet artiste styliste et designer de collections limitées de meubles. Pour lui, une chose est sûre: « mon environnement et mon travail s'influencent mutuellement de manière extraordinaire ».

*Frank Leder uses his apartment as a studio, where he works as a fashion and furniture designer.*

*Frank Leder nutzt seine Wohnung auch als Studio für seine Arbeit als Mode- und Möbeldesigner.*

*Frank Leder utilise son appartement également comme studio pour pratiquer son métier de styliste et de designer de meubles.*

Collector's Paradise | 89

*Frank Leder added a coat of gray paint to the wooden wall paneling.*

*Die Wandvertäfelung aus Holz hat Frank Leder grau überstrichen.*

*Les boiseries murales ont été repeintes en gris par Frank Leder.*

*The ornate stove in the dining room is still used to heat the apartment. The owner built the bookcase from cubes and cuboids that can be flexibly rearranged.*

*Bis heute lässt sich der prunkvolle Ofen im Esszimmer heizen. Das Bücherregal aus selbstgebauten Würfeln und Quadern ist flexibel in der Anordnung.*

*Le poêle tape-à-l'œil réchauffe encore et toujours la salle à manger. L'étagère de livres, composée de cubes et pavés droits bricolés, peut être assemblée de manière différente.*

*Fashion designer Frank Leder bought many pieces of furniture and curios from online auctions and flea markets.*

*Viele Möbel und Kuriositäten hat Modedesigner Frank Leder im Internet ersteigert und auf Flohmärkten gefunden.*

*Le designer-styliste, Frank Leder, a acheté de nombreux meubles et autres curiosités dans des ventes aux enchères sur internet et sur des marchés aux puces.*

# Mirror, Mirror on the Wall
## Mitte

THE DESIGN FOR this two-floor apartment came about through a competition. Part private residence, part showcase apartment, the 4,300-square-foot property originally had a conventional floor plan with a great many small rooms. The architects turned the lower floor into a large, central reception room, dominated by mirror-lined walls that reflect the light and create a muted ambience. Wood, concrete, and glass give the Mirror Loft a timeless charm, despite its modern appearance. Three guest rooms lead off a long corridor decorated in black. "The hallway has a 1920s look and feel, with a hint of Berlin history," says interior designer Fabian Freytag. The second floor accommodates the master bedroom, and there is also a 1,100-square-foot rooftop terrace with a breathtaking view of Berlin.

AUS EINEM WETTBEWERB gingen die Pläne für die Gestaltung der halb privat, halb repräsentativ genutzten Maisonettewohnung hervor. Das 400-Quadratmeter-Objekt war ursprünglich eine konventionell geschnittene Wohnung mit vielen kleinen Zimmern. Die Architekten machten daraus im unteren Geschoss einen großen, zentralen Raum für Empfänge. Ihn dominiert ein Einbau aus verspiegeltem Glas, der Lichtstimmungen verzerrt reflektiert. Holz, Beton oder Glas geben dem Spiegelloft trotz seiner Modernität einen zeitlosen Charme. Von einem langen, schwarz gehaltenen Flur gehen drei Gästezimmer ab. „Der Flur nimmt die Ästhetik der 20er Jahre auf und spielt auf die Geschichte Berlins an", sagt Innenarchitekt Fabian Freytag. Oben befinden sich der Masterbedroom und die 100 Quadratmeter große Dachterrasse mit einem atemberaubenden Blick über Berlin.

LA SÉLECTION DES plans de réaménagement de cette maisonnette, utilisée à des fins privées et dans un but représentatif, a fait l'objet d'un appel d'offres. Ce bien immobilier de 400 mètres carrés était à l'époque un appartement conventionnel, composé de plusieurs petites pièces. Les architectes ont transformé le rez-de-chaussée en une grande salle centrale de réception. La pièce maîtresse qui domine la salle est composée de verre réfléchissant, dans laquelle se reflète une lumière altérée. Le bois, le béton et le verre confèrent au loft aux miroirs un charme intemporel malgré sa modernité. Le long couloir noir donne sur trois chambres. « Le style du couloir rappelle celui du Berlin des années 20 », déclare l'architecte d'intérieur Fabian Freytag. A l'étage, on trouve la chambre à coucher principale et la grande terrasse de 100 mètres carrés située sur le toit, de laquelle on peut admirer Berlin.

*The hallway where the guest rooms are located features black décor, reflecting the style of the Roaring Twenties.*

*Der Flur mit den Gästezimmern ist schwarz gehalten, eine Anspielung auf den Stil der Goldenen Zwanziger.*

*Le couloir qui mène aux chambres des invités est plongé dans des tons de noir qui rappellent le style des années folles.*

The rooms are arranged in the shape of a funnel. At the heart of the apartment lies the kitchen whose walls are lined with mirrors reflecting the light for a muted ambience in the penthouse.

Die Räume der Wohnung sind trichterförmig angeordnet. Der verspiegelte Einbau mit Küche, der die jeweilige Lichtstimmung im Penthouse reflektiert, bildet das Zentrum.

La disposition des pièces de l'appartement rappelle un entonnoir. La cuisine, sertie de miroirs qui font refléter la lumière du jour dans le penthouse, constitue le centre de l'appartement.

# Bohemian Chic
## Mitte

IN A CLASSIC old building in the Mitte district, a den, living room, and bedroom are connected by double doors that are usually left open. And that's not all. "The line of sight is intended to make you want to explore the rest of the rooms," the owner explains. She accomplishes this goal with cleverly placed furnishings that create a balance between contemporary design and tradition. Heavy, upholstered furniture contrasts with hip designer lamps. The accessories include handpicked pieces such as ashtrays made of Murano glass that she found at flea markets all over Europe. The book-patterned wallpaper definitely catches the eye. "My good friend, Frank Stüve of Villa Harteneck, found it in England. I wasn't completely won over at first, but now I am eternally grateful that I took his advice."

EINE KLASSISCHE ALTBAUWOHNUNG in Mitte: Arbeitszimmer, Salon und Schlafzimmer sind durch Flügeltüren miteinander verbunden, die meistens offen stehen. Doch nicht nur das: „Die Blickachsen sollen auch bewusst neugierig machen auf die dahinterliegenden Räume", erläutert die Hausherrin. Das gelingt ihr durch eine geschickt positionierte Einrichtung, die den Spagat zwischen Moderne und Tradition schafft. Schwere Polstermöbel treffen auf hippe Designerleuchten. Unter den Accessoires sind handverlesene Einzelstücke wie Aschenbecher aus Muranoglas von Flohmärkten in ganz Europa. Ein Hingucker ist die Buchtapete. „Mein guter Freund Frank Stüve von der Villa Harteneck hat sie in England entdeckt. Ich war mir anfangs nicht ganz sicher, aber jetzt freue ich mich jeden Tag, seinem Rat gefolgt zu sein."

UN ANCIEN APPARTEMENT classique dans le quartier Mitte : bureau, salon et chambre à coucher sont séparés de portes à double battants qui sont ouvertes en permanence. Mais ce n'est pas tout : « les angles de vue sont censés éveiller la curiosité sur les pièces qui se cachent derrière », déclare la maitresse de maison. Le résultat est réussi grâce à la position de l'aménagement, qui concilie moderne et traditionnel. Des meubles rembourrés sont combinés aux luminaires design tendance. Les divers accessoires comptent des pièces triées sur le volet comme les cendriers en verre Murano qui proviennent des marchés aux puces de toute l'Europe. Le point de mire de l'ensemble constitue le papier peint. « Mon cher ami Frank Stüve de la Villa Harteneck l'a découvert en Angleterre. Je n'étais pas convaincue au début, mais aujourd'hui je ne regrette pas d'avoir suivi son conseil. »

*The book-patterned wallpaper comes from England. It provides a tongue-in-cheek contrast to the white walls in the rest of the home. The painting above the bed is by Willem de Rooij.*

*Die Buchtapete kommt aus England. Mit einem Augenzwinkern schafft sie einen schönen Kontrast zu den übrigen weißen Wänden. Das Bild über dem Bett ist von Willem de Rooij.*

*La tapisserie provient d'Angleterre et contraste en un clin d'œil avec les murs blancs restants. La peinture au-dessus du lit est une œuvre de Willem de Rooij.*

*The dove installation was created by the artist twins Maria and Natalia Petschatnikov. The message board in the hall comes from a second-hand shop.*

*Die Tauben-Installation stammt von den Zwillingen Maria und Natalia Petschatnikov. Das Board im Flur ist vom Trödler.*

*L'installation de colombes est une œuvre des jumelles Maria et Natalia Petschatnikov. Le bahut dans le couloir provient d'un brocanteur.*

112 | Bohemian Chic

# Loft in Kreuzberg
## Kreuzberg

THIS BRIGHT AND inviting loft is situated in the heart of Berlin, not far from Potsdamer Platz. When the current owner took over the apartment, it was furnished entirely in white. He found the décor lacking in warmth and added a bit of color to the chairs, footstools, and sofa designed in the style of Ludwig Mies van der Rohe's Barcelona collection. In the living room, he combined colorful kilims from a Belgian company with the classic white furniture. Built-in bookshelves and doors added a cozy feel to the loft and provided space for books. Elliott Erwitt photographs hang on the walls and look most striking on the unplastered surfaces in the living room. The kitchen has a purist design. Like in the rest of the apartment, large windows ensure that this room is filled with light.

MITTEN IM ZENTRUM Berlins, nicht weit vom Potsdamer Platz entfernt, liegt dieses helle und freundliche Loft. Als es der jetzige Eigentümer übernahm, war es ganz in Weiß eingerichtet. Zu kühl, befand der neue Bewohner, und fügte den Sesseln, dem Sofa und den Hockern im Stil der Barcelona-Kollektion von Ludwig Mies van der Rohe etwas Farbe hinzu. So kombinierte er im Wohnzimmer bunte Kelim-Teppiche von einer belgischen Firma zu den weißen Klassikern. Durch Einbauten wie Türen und Regale wurde das Loft wohnlicher und es entstand Platz für Bücher. An den Wänden hängen Fotografien von Elliott Erwitt. Sie entfalten ihre Wirkung besonders vor den unverputzten Wänden im Wohnzimmer. Die Küche zeichnet sich durch ein puristisches Design aus. Auch sie ist dank der großen Fenster lichtdurchflutet.

CE LOFT LUMINEUX est situé en plein centre de Berlin, près de la Potsdamer Platz. Lorsque le propriétaire actuel l'a acquis, celui-ci était entièrement décoré en blanc. L'aménagement paraissait trop froid au nouvel occupant qui s'empressa d'apporter une touche chaleureuse de couleurs aux fauteuils, au divan et aux tabourets de la collection Barcelona de Ludwig Mies van der Rohe. Dans le salon, il a ajouté des tapis kilim aux mille couleurs, qu'il a achetés à une entreprise belge. L'installation d'étagères et de portes a rendu le loft plus confortable et le propriétaire a maintenant assez de place pour ranger ses livres. Les murs non crépis du salon sont décorés de photographies d'Elliott Erwitt et soutiennent l'effet des images. La cuisine, inondée de lumière grâce à sa grande fenêtre, se distingue par son design puriste.

Loft in Kreuzberg | 117

The homeowner combined classic white furniture with colorful kilims. He added doors and built-in bookcases, creating space to display his books.

Zu den weißen Klassikern kombinierte der Hausherr bunte Kelims. Türen und Regale ließ er einbauen und gewann damit Raum zur Präsentation seiner Bücher.

Le maître des lieux a combiné des kilims multicolores aux classiques de blanc. Il a fait concevoir les portes et les étagères afin de donner de l'espace à la présentation de ses livres.

120 | Loft in Kreuzberg

121

# Back in the Days
## Mitte

SOHO HOUSE, AN international chain of private members' clubs, is a gathering place for creative people. Berlin is home to the only Soho House club in Germany, and it includes a spa, restaurants, and bars as well as more than 65 hotel rooms and 20 apartments. "Many of our members are in Berlin to work on long-term projects, and they have requested fully furnished apartments," explains Heide Proett, the club's spokesperson. Soho House founder Nick Jones and his team furnished the 20 apartments with a mix of vintage furniture and custom-made objects, and they will add four spacious lofts by the end of 2013. The apartments radiate the faded splendor of the 1920s, when this former department store was built in 1928 in the style of New Objectivity architecture. Everyone is welcome here, even those who are not club members.

DIE WELTWEITEN HÄUSER des „Private Member Clubs" Soho House sind ein Treffpunkt für Kreative. In Berlin steht das einzige deutsche Haus, das neben einem Spa, Restaurants und Bars über 65 Hotelzimmer und 20 Appartements verfügt. „Viele unserer Mitglieder sind beruflich für längere Projekte in der Stadt und äußerten den Wunsch nach komplett ausgestatteten Wohnungen", erklärt Heide Proett, Sprecherin des Hauses. Soho House-Gründer Nick Jones und sein Team richteten die 20 Appartements, die ab Ende 2013 durch vier geräumige Lofts ergänzt werden, mit einer Mischung aus Vintage-Möbeln und maßgeschneiderten Objekten ein. Sie versprühen den verblassten Glanz der 20er Jahre, als das Gebäude 1928 als Kaufhaus im Stil der Neuen Sachlichkeit gebaut wurde, und stehen auch Gästen offen, die keine Club-Mitglieder sind.

LES ÉTABLISSEMENTS DU « Private Member Club » Soho House sont les points de rencontre des créatifs à travers le monde. L'unique établissement allemand dispose de 65 chambres d'hôtel, 20 appartements, de restaurants et d'un centre de bien-être. « Nombreux sont nos clients qui séjournent dans la ville pendant une longue période dans le cadre de leurs projets et ont exprimé le souhait de disposer d'appartements entièrement équipés », affirme Heide Proett, porte-parole de l'établissement. Le fondateur de Soho House, Nick Jones, et son équipe ont aménagé 20 appartements et depuis la fin 2013, quatre lofts spacieux composés d'un mélange de meubles vintages et d'objets sur mesure. Ils dégagent la splendeur défraîchie de la fin des années 20, tout en faisant honneur à ce bâtiment qui a été construit en 1928 comme un grand magasin dans le style de la Nouvelle Objectivité. Les appartements accueillent également une clientèle qui n'est pas membre du club.

*The interior design team collected unusual accessories and books from antique stores. The beds were made to order.*

*Originelle Accessoires und Bücher hat das Interior-Design-Team aus Antiquariaten zusammengetragen. Die Betten sind Spezialanfertigungen.*

*L'équipe de designers s'est procuré les accessoires originaux et les livres dans une boutique d'antiquités. Les lits ont été construits sur mesure.*

*While the floors and furniture have been allowed to develop a patina, everything in the fully equipped, customized kitchen is of the finest quality.*

*Auch wenn Boden und Möbel Patina haben dürfen, ist in der maßgefertigten und voll ausgestatteten Küche alles vom Feinsten.*

*Malgré la patine du sol et des meubles, la cuisine, faite sur mesure et entièrement équipée, est au comble du raffinement.*

*Even the bathroom radiates the elegance of the late 1920s, combined with the style of a British country manor.*

*Die Eleganz der späten 20er Jahre gepaart mit britischem Landhausstil wird auch im Bad gepflegt.*

*Dans la salle de bains se combine l'élégance de la fin des années 20 avec le style de cottage britannique.*

# Rooms with a View
## Friedrichshain

IN CHRISTOPH TOPHINKE'S opinion, the best part of his home is the view. This is hardly surprising, since he lives in one of the towers in the buildings on Frankfurter Tor that date back to the Stalin era and are under historic preservation. However, it is not always easy to live in a tower. "All the walls are either round or have windows," says the proprietor, who therefore had to give up many pieces of furniture when he moved in. Tophinke runs Chelsea Farmers Club, a shop in Charlottenburg that sells British menswear, and holds events for his club members in the tower. A private elevator connects the apartment's four floors. The third floor contains the kitchen, which has a small bar designed by the homeowner himself. On the top floor, guests can sit on two comfortable Chesterfield sofas under the illuminated cupola and set down their drinks on a stuffed bear.

DIE AUSSICHT LIEBT der Hausherr an seiner Location ganz besonders. Kein Wunder, befindet sie sich doch in einem der Türme in den denkmalgeschützten Stalinbauten am Frankfurter Tor. Doch in einem Turm zu leben, ist nicht immer leicht: „Alle Wände sind entweder rund oder verglast", sagt Christoph Tophinke, der mit dem Chelsea Farmers Club in Charlottenburg ein Geschäft für britische Herrenmode betreibt und den Turm als Event-Location für seine Club-Mitglieder nutzt. Von vielen Möbeln musste er sich daher beim Umzug trennen. Die vier Stockwerke der Wohnung sind durch einen eigenen Fahrstuhl verbunden. Im dritten ist die Küche mit einer kleinen Bar, die der Eigentümer selbst entworfen hat. Ganz oben kann man unter der illuminierten Kuppel auf zwei gemütlichen Chesterfield-Sofas Platz nehmen und sein Getränk auf einem ausgestopften Bären abstellen.

LE MAÎTRE DE maison affectionne particulièrement la vue du lieu. Rien d'étonnant si l'on considère qu'il s'agit d'une des tours du bâtiment stalinien, classé monument historique, de la Frankfurter Tor. Vivre dans une tour n'est pourtant pas toujours facile : « Tous les murs sont soit arrondis, soit recouverts de verre », affirme Christoph Tophinke, qui gère le Chelsea Farmers Club, une boutique de mode masculine britannique à Charlottenburg. Il a donc dû se séparer de nombreux meubles lors du déménagement. Les quatre étages de l'appartement sont desservis par un ascenseur. La cuisine, située au troisième étage, est composée d'un bar que le propriétaire a conçu personnellement. Les deux fauteuils Chesterfield de l'étage supérieur, surplombés d'une coupole illuminée, invitent à la détente, et l'ours empaillé à leurs côtés sert de repose-verre.

*The founder of a store for British men's clothing lives in the tower of a 1950s flagship building that is typical of the Socialist classicism. He has a passion for curiosities such as taxidermy.*

*Im Turm eines sozialistischen Vorzeigebaus aus den 50er Jahren wohnt der Gründer eines Geschäfts für britische Herrenbekleidung. Er hat ein Faible für Skurrilitäten wie präparierte Tiere.*

*Le fondateur d'une boutique de mode masculine britannique habite la tour de ce joyau architectural de l'époque du socialisme des années 50. Il a un faible pour les bizarreries comme les animaux empaillés.*

Rooms with a View | 135

*The apartment occupies four floors, which means that the homeowner must either climb stairs or use the small, wooden elevator.*

*Da sich seine Wohnung über vier Stockwerke erstreckt, muss der Hausherr entweder Treppen steigen oder den kleinen hölzernen Fahrstuhl benutzen.*

*Pour se déplacer dans son appartement qui s'étend sur quatre étages, le maitre des lieux doit emprunter les escaliers ou le petit ascenseur en bois.*

Rooms with a View | 141

# Stylish Art Lovers
## Dahlem

WHEN RACKHAM F. Schröder, CEO of Engel & Völkers Commercial, renovated his home in Dahlem, he rebuilt the place practically from the ground up. The builders removed many of the walls and turned a large number of small rooms into one big salon. The kitchen, dining room, living room, and library flow into each other. Their parquet floors are made of fumed oak. The second floor accommodates the adult and children's bedrooms. The house bears the hallmarks of architect Gesine Weinmiller, whose rectilinear style lends the rooms symmetry and tranquility. Villa Harteneck came up with the color scheme, and the homeowners brought most of their furniture with them when they moved in. Their passion for contemporary art can be seen in the many paintings, photographs, and art objects scattered throughout the house.

KAUM EIN STEIN ist im Inneren des Dahlemer Einfamilienhauses von Rackham F. Schröder, Geschäftsführer von Engel & Völkers Commercial, bei der Sanierung auf dem anderen geblieben. Im Untergeschoss wurden zahlreiche Wände entfernt, um aus vielen kleinen einen großen Raum zu machen. Küche, Ess- und Wohnzimmer sowie die Bibliothek gehen ineinander über. Sie sind mit einem Parkett aus Räuchereiche ausgelegt. Oben befinden sich die Schlaf- und Kinderzimmer. Das Haus trägt die Handschrift von Architektin Gesine Weinmiller. Ihr geradliniger Stil gibt den Räumen Symmetrie und Ruhe. Beim Farbkonzept half die Villa Harteneck, wobei die Bauherren die meisten Möbel bereits mitbrachten. Ihr Faible für zeitgenössische Kunst drückt sich in zahlreichen Gemälden, Fotografien und Objekten aus, die im gesamten Haus verteilt sind.

L'INTÉRIEUR DE LA maison de Rackham F. Schröder, directeur général d'Engel & Völkers Commercial, a été complètement transformé lors de sa rénovation. Les murs du rez-de-chaussée ont été abattus pour laisser place à une salle spacieuse. Les pièces de la cuisine, de la salle à manger et du salon ainsi que de la bibliothèque s'enchainent les unes aux autres et sont parquetées de chêne fumé. L'étage supérieur abrite la chambre à coucher des parents et celle des enfants. La maison est signée de la main de l'architecte Gesine Weinmiller. Son style rectiligne confère aux pièces une certaine symétrie et une atmosphère de calme. Le concept coloré s'inspire de la Villa Harteneck, bien que les maîtres d'ouvrage y aient apporté la majorité des meubles. Leur faible pour l'art contemporain se traduit dans les nombreux tableaux, photographies et objets qui décorent l'ensemble de la maison.

*On the ground floor, the open kitchen, dining room, living room, and library flow into each other. The wall and ceiling grids provide structure.*

*Im Erdgeschoss gehen die offene Küche, das Ess- und Wohnzimmer sowie die Bibliothek ineinander über. Struktur bieten die Wand- und Deckenraster.*

*La cuisine ouverte, la salle à manger, le salon et la bibliothèque s'enchainent les unes aux autres au rez-de-chaussée. L'ossature des murs et du plafond donne une structure à l'ensemble.*

*The homeowners are dedicated art collectors. The large works of art in the hall are by Barbara Probst.*

*Die Bauherren sind begeisterte Kunstsammler. Die großformatigen Werke im Flur sind von Barbara Probst.*

*Les maîtres d'ouvrage sont des collectionneurs d'art convaincus. Les œuvres grand format du couloir sont signées Barbara Probst.*

A kitchen from Bulthaup forms the heart of the house. Its industrial look creates a sober contrast to the fumed oak parquet floor.

*Das Zentrum des Hauses ist die Küche von Bulthaup, deren industrieller Look einen kühlen Kontrast zum Parkett aus Räuchereiche bildet.*

*La cuisine de Bulthaup constitue le centre de la maison. Son style industriel contraste froidement avec le parquet en chêne fumé.*

150 | Stylish Art Lovers

151

The skateboard in the display case is a work of art by Ólafur Elíasson. The homeowners commissioned architect Gesine Weinmiller to handle the renovations. She also designed the bookcases.

Das Skateboard in der Vitrine ist ein Kunstwerk von Ólafur Elíasson. Die Bücherregale ließen die Bauherren wie den gesamten Umbau von Architektin Gesine Weinmiller planen.

Le skateboard dans la vitrine est une œuvre d'Ólafur Elíasson. Gesine Weinmiller a conçu les étagères de livres. L'architecte s'est également occupée de l'ensemble de la restructuration pour le compte des maîtres de maison.

# Private Gallery
## Mitte

MARCUS DESCHLER LIVES in an apartment above his contemporary art gallery in an old building. At one time, three apartments occupied the space, but the gallery owner removed several walls and created a number of spacious rooms. He still had enough wall space to hang his art. Many pieces found a permanent home even before the furniture arrived. "Äste" (Branches), an installation by Hans van Meeuwen, welcomes visitors as they enter the living room. "Rapsfeld vor Berlin" (Canola Field Outside Berlin), a painting by Rainer Fetting, hangs on the opposite wall. "I love large formats," says Marcus Deschler. "They give the room structure." He even has art in the kitchen, which was built into a traditional, Berlin-style connecting room, in the form of a wallpaper installation. The homeowner took a pragmatic approach to the furnishings, with Ligne Roset sofas that each seat up to 15 guests during parties.

DIREKT ÜBER SEINER Galerie für zeitgenössische Kunst liegt Marcus Deschlers Altbauwohnung. Eigentlich waren es mal drei. Der Galerist ließ mehrere Wände herausnehmen und schaffte damit großzügige Räume. Trotzdem gibt es noch ausreichend Platz, um seine Kunst aufzuhängen. Viele Arbeiten hatten schon ihren festen Ort gefunden, bevor die Möbel in der Wohnung standen. Besucher werden im Wohnzimmer von Hans van Meeuwens Installation „Äste" begrüßt. Gegenüber hängt das Bild „Rapsfeld vor Berlin" von Rainer Fetting. „Ich liebe Großformate, sie strukturieren den Raum", erklärt Marcus Deschler. In der Küche, die er im Berliner Zimmer einbauen ließ, hängt ebenfalls Kunst in Form einer Tapeten-Installation. Die Einrichtung hielt der Hausherr pragmatisch: Auf jedem der Ligne Roset-Sofas finden bei Partys bis zu 15 Gäste Platz.

L'APPARTEMENT ANCIEN DE Marcus Deschler est situé à l'étage supérieur de sa galerie d'art contemporain. A l'époque, il s'agissait en fait de trois appartements. Le galeriste a fait abattre la majorité des murs pour laisser place à des pièces spacieuses. Il lui reste cependant encore assez d'espace pour accrocher toutes ses œuvres d'art dont la plupart avaient déjà trouvé leur place avant l'arrivée des meubles. Les invités sont accueillis dans le salon par « Äste » (Branches), une création de Hans van Meeuwen, qui fait face à un tableau de Rainer Fetting, « Rapsfeld vor Berlin » (Champ de colza près de Berlin). Marcus Deschler déclare : « J'aime les grands formats, ils structurent les pièces ». La cuisine, installée dans la « Berliner Zimmer » (une pièce de passage), est également décorée d'une installation artistique en papier peint. L'intérieur a été aménagé par le maître des lieux de manière pragmatique : chaque divan Ligne Roset peut accueillir jusqu'à 15 personnes lors de soirées.

*Art, art everywhere: "The Dreamer," a piece by Lies Maculan, occupies the center of the room. Tony Conway's painting titled "ROPPONGI" hangs on the wall. The kitchen was built into a traditional Berlin-style connecting room, where a duck by Deborah Sengl can be seen "flying."*

*Kunst, wohin man schaut: In der Mitte des Raumes ist Lies Maculans Werk „The Dreamer", an der Wand Tony Conways Bild mit dem Titel „ROPPONGI". Die Küche wurde im Berliner Zimmer eingebaut. Dort „fliegt" auch die Ente von Deborah Sengl.*

*L'art est ici omniprésent. Au milieu de la pièce, on se retrouve face à l'œuvre de Lies Maculan « The Dreamer », le tableau de Tony Conway « ROPPONGI » pend au mur. La cuisine a été installée dans une pièce de passage où un canard de Deborah Sengl prend son envol.*

Private Gallery | 159

Marcus Deschler had the bookcase built into the frame of a set of double doors.

Das Bücherregel ließ Marcus Deschler in den Rahmen einer Flügeltür einbauen.

Marcus Deschler a fait construire son étagère à livres dans l'embrasure d'une porte à deux battants.

*The homeowner values interesting lines of sight. On the floor, wooden planks alternate with intarsia parquet.*

*Interessante Sichtachsen sind dem Hausherren wichtig. Holzdielen und Intarsienparkett wechseln sich als Bodenbelag ab.*

*Le maître des lieux accorde beaucoup d'importance aux angles de vue hors du commun. Le sol est composé en alternance de planches de bois et d'un parquet marqueté.*

# Color Me Softly
## Grunewald

THE ARCHITECTURAL FIRM cpm architekten combined two apartments into one for an art-loving homeowner. It covers three floors of a building near a lake in Grunewald. The ground floor has a twelve-foot ceiling and accommodates a kitchen/living area decorated in walnut. A striking, spiral staircase made of steel stands next to a brilliant red wall and leads to the second floor, where the living room features yellow and green hues that blend harmoniously with the light-colored maple parquet floor. The most private part of the home, with the bedroom, a spacious bathroom, and a dressing room, is situated on the third floor. The open floor plan provides plenty of space for the furniture, artworks, and sculptures that the owner has collected over his lifetime. Five small windows were even sealed off for two large paintings by Salomé and Rainer Fetting.

FÜR EINEN KUNSTBEGEISTERTEN Bauherren hat das Büro cpm architekten aus zwei Wohnungen eine gemacht. Nahe des Grunewalder Hundekehlesees erstreckt sie sich nun über drei Etagen. Vom 3,60 Meter hohen Erdgeschoss mit einer Wohnküche in Nussbaum gelangt man über eine imposante Stahl-Wendeltreppe vor einer leuchtend roten Wand in den ersten Stock. Dort ist das Wohnzimmer in gelb-grünen Zitrustönen gehalten, die perfekt mit dem hellen Ahornparkett harmonieren. Darüber liegt der intimste Teil der Wohnung mit Schlafzimmer, geräumigem Bad und Ankleide. Die Möbel, Kunstwerke und Skulpturen, die der Eigentümer im Laufe seines Lebens gesammelt hat, finden dank der offenen Raumgestaltung reichlich Platz. Für zwei großformatige Werke von Salomé und Rainer Fetting wurden sogar fünf kleine Fenster geschlossen.

LE CABINET D'ARCHITECTES cpm architekten a aménagé deux appartements en un seul pour un client amoureux de l'art. L'appartement, situé à proximité d'un lac dans le quartier Grunewald, s'étend sur trois étages. Du rez-de-chaussée d'une hauteur de plafond de 3,60 mètres qui abrite une cuisine en noyer, on accède au premier étage par un escalier en colimaçon en acier entouré d'un mur rouge. Dans le salon, des tons jaune-vert citron dominent, s'harmonisant parfaitement au parquet en érable clair. L'étage supérieur abrite la partie privée : la chambre à coucher, la salle de bains spacieuse et le dressing. Les meubles, œuvres d'art et sculptures que le propriétaire a acquis tout au long de sa vie, s'épanouissent grâce à l'espace généreux que confère l'aménagement du lieu. Cinq petites fenêtres ont même été condamnées afin d'accueillir deux œuvres monumentales de Salomé et Rainer Fetting.

The apartment occupies three floors of a Grunewald apartment complex. The second floor is decorated in citrus yellow, which lends the space a sense of lightness.

Über drei Etagen erstreckt sich die Wohnung in einer Grunewalder Wohnanlage. Das erste Obergeschoss ist in Zitrusfarben gehalten, die die Leichtigkeit der Etage betonen.

L'appartement est situé dans un complexe du Grunewald et s'étend sur trois étages. Le premier étage est dominé de tons citron qui lui confèrent une certaine légèreté.

The apartment's open floor plan provides plenty of space for the furniture and sculptures that the homeowner has collected over the course of his eventful life.

*Durch den offenen Grundriss ist in der Wohnung ausreichend Platz für Möbel und Skulpturen, die der Hausherr im Laufe seines bewegten Lebens gesammelt hat.*

*La mise en plan ouverte de l'appartement permet d'accueillir de nombreux meubles et sculptures que le maitre des lieux a assemblé tout au long sa vie agitée.*

168 | Color Me Softly

*The steel spiral staircase, which is nearly 13 feet high, didn't fit through the openings in the façade during the renovations. Instead, it had to be taken apart and then welded back together again.*

*Weil die fast vier Meter hohe Stahlwendeltreppe beim Umbau nicht durch die Fassadenöffnungen passte, musste sie erst zerteilt und dann wieder zusammengeschweißt werden.*

*L'escalier en colimaçon en acier, de presque quatre mètres de hauteur, ne pouvait être introduit par les ouvertures de la façade lors de la rénovation. Il a donc fallu le démonter pour le ressouder ensuite dans l'appartement.*

Old photographs of Berlin hang in the ground-floor guest room and provide a striking contrast to the gold-toned furniture.

Im Gästezimmer im Erdgeschoss hängen alte Berlin-Aufnahmen, die einen spannenden Kontrast zu den in Gold gehaltenen Möbeln bilden.

Des anciennes photographies de Berlin arpentent les murs de la chambre des invités du rez-de-chaussée et contrastent avec les meubles revêtus d'or.

Color Me Softly | 173

# Joy & Jewelry
## Charlottenburg

BEFORE LILO BENECKE became a jewelry designer, she owned a gallery. Her former occupation is reflected in the many art works in her 2,900-square-foot apartment in an old building. Paintings and sculptures are placed throughout the home. The entire art collection, e.g., the bright pink sheep by Peter Panyoczki, forms a vibrant contrast to the straight lines of the furniture, some of which dates back to the 1930s. "That decade saw the emergence of modernism, which encompassed everything," says Lilo Benecke. "What I like about the furniture and art objects is that stylistically they are a true representation of a unique and uncompromisingly dogmatic period." She found many pieces in antique stores and at outdoor markets. When designing her jewelry, she sits at a 16-foot sliding-leaf table from Knoll. She launched her career by reworking some pieces of old family jewelry to suit her own tastes. Today she sells her work in select shops.

BEVOR LILO BENECKE Schmuckdesignerin wurde, führte sie eine Galerie. Das zeigt sich an den vielen Kunstwerken in ihrer 270 Quadratmeter großen Altbauwohnung. Überall hängen und stehen Bilder und Skulpturen. Insgesamt – wie das Bild eines pinken Schafes von Peter Panyoczki – bilden sie einen lebendigen Kontrast zu den geradlinigen Möbeln, von denen einige aus den 30er Jahren stammen. „Dies war der alles ergreifende Aufbruch der Moderne. Mir gefällt an den Möbeln und Objekten, dass sie ein authentisches Zeugnis einer konsequent dogmatischen, einmaligen Stilepoche sind", sagt Lilo Benecke. Viele Stücke fand sie in Antiquitätenläden und auf Märkten. Ihr Schmuck entsteht an einem fünf Meter langen Ausziehtisch von Knoll. Mit dieser Profession begann sie, als sie alten Familienschmuck nach ihrem Geschmack umarbeitete. Heute vertreibt sie ihre Eigenkreationen über ausgewählte Geschäfte.

AVANT DE SE lancer dans la création de bijoux, Lilo Benecke tenait une galerie d'art. Pas étonnant si l'on considère les nombreuses œuvres d'art qui arpentent les 270 mètres carrés de son appartement ancien, garni de peintures et de sculptures. La majorité de ces œuvres, tout comme le mouton d'un rose vif de Peter Panyoczki, contrastent vivement avec le style rectiligne des meubles, dont certains proviennent des années 30. « Ils rappellent le renouveau émouvant de la modernité. Ce qui me plait, c'est que ces meubles et objets sont la preuve authentique d'une époque de style résolument dogmatique et unique », affirme Lilo Benecke. Nombreuses de ces pièces proviennent des boutiques d'antiquités ou des marchés. Elle confectionne ses bijoux sur une table à rallonges de cinq mètres de Knoll. En transformant des bijoux anciens d'après ses goûts, elle a débuté dans la profession. Aujourd'hui, plusieurs boutiques sélectes vendent ses créations.

*The Markus Lüpertz sculpture stands in front of a Chinese screen. The homeowner is fond of furniture from the 1930s. The chairs in her living room, as well as other pieces, date back to this period.*

*Die Skulptur von Markus Lüpertz steht vor einem chinesischen Paravent. Die Hausherrin hat eine Vorliebe für Möbel aus den 30er Jahren. Unter anderem stammen die Sessel im Wohnzimmer aus dieser Zeit.*

*La sculpture de Markus Lüpertz fait face à un paravent chinois. La maîtresse des lieux affectionne particulièrement les meubles des années 30. Les fauteuils du salon, entre autres, proviennent de la même époque.*

Joy & Jewelry | 177

As an art collector and former gallery owner, Lilo Benecke is passionate about the work of Herbert Zangs, a contemporary of Joseph Beuys. The kitchen is open on all sides.

Als ehemalige Galeristin und als Sammlerin ist Lilo Benecke von den Arbeiten von Herbert Zangs begeistert, einem Zeitgenossen von Joseph Beuys. Die Küche ist zu allen Seiten hin offen.

En tant qu'ancienne galeriste et collectionneuse, Lilo Benecke admire les travaux d'Herbert Zangs, un contemporain de Joseph Beuys. La cuisine est ouverte de toutes parts.

Joy & Jewelry | 183

*Sliding doors connect some of the rooms in the spacious apartment in an old building, creating attractive lines of sight.*

*Einige Räume der großzügigen Altbauwohnung sind durch Schiebetüren verbunden. Dadurch ergeben sich attraktive Sichtachsen.*

*Quelques pièces de cet ancien appartement spacieux communiquent par des portes coulissantes – ce qui confère aux pièces des angles de vue assez attractifs.*

# Modern Glamour
## Wilmersdorf

THIS MULTISTORY APARTMENT covers the fifth and sixth floors of an exclusive residential complex with a rough-hewn stone façade not far from the Ku'damm. In designing built-in features such as closets, kitchen, and bathroom cabinets, architect Britt Eckelmann of cpm architekten took her cue from the building's external appearance. Painted a matte white, these elements are combined with the warmth of walnut wood and accented by shiny chrome trim and handles. The architect changed the floor plan so that the two guest rooms, which share a kitchenette, are separated from the rest of the apartment by a sliding door. The apartment no longer has any hallways. Instead, the spacious rooms flow seamlessly into each other. A staircase with a glass railing connects the two floors, so that natural light fills the downstairs rooms from above.

NICHT WEIT VOM Ku'damm erstreckt sich diese Maisonette-Wohnung über die fünfte und sechste Etage einer exklusiven Wohnanlage mit Bossenputzfassade. Architektin Britt Eckelmann vom Büro cpm architekten nahm bei der Gestaltung der Einbaumöbel wie Garderoben, Küchen und Badschränke Bezug auf die äußere Gestalt des Hauses: Sie sind in mattem Weißlack gehalten und mit warmem Nussbaumholz kombiniert. Akzente setzen Blenden und Griffe in strahlendem Chrom. Der Grundriss wurde so verändert, dass sich die beiden Gästezimmer mit gemeinsamer Kitchenette durch eine Schiebetür vom Rest der Wohnung abtrennen lassen. Es gibt keine Flure mehr, stattdessen gehen die großzügigen Räume fließend ineinander über. Beide Geschosse sind durch eine Treppe mit Glasgeländer verbunden, sodass Tageslicht von oben in die unteren Räume fällt.

SITUÉE NON LOIN du Ku'damm, cette maisonnette-appartement occupe les cinquième et sixième étages d'un complexe d'appartements dont la façade est ornée de bossage. L'architecte, Britt Eckelmann du cabinet cpm architekten, s'est inspirée du genre de l'édifice pour la conception des meubles encastrés dans le vestiaire, la cuisine et la salle de bains : un mélange de noyer et de laque blanche mate, accentué par les arcades et poignées en chrome brillant. Le plan d'origine a été modifié afin de séparer les deux chambres des invités et leur kitchenette du reste de l'appartement par une porte coulissante. Les couloirs sont inexistants, les pièces spacieuses se fondent de manière continue les unes dans les autres. Les deux étages sont reliés par un escalier avec une rampe en verre qui permet à la lumière du jour d'éclairer les pièces inférieures.

*Black granite dominates the bathrooms. Indirect lighting and light-colored walls add lightness to the otherwise heavy décor.*

*In den Bädern dominiert schwarzer Granit. Durch die indirekte Beleuchtung der Wände und helle Wandfarben wurde ihm die Schwere genommen.*

*Le granit noir domine les salles de bains. L'illumination indirecte et les couleurs claires des murs leur confèrent par contre une certaine légèreté qui contraste avec la lourdeur de la couleur ébène.*

*A steel staircase with glass railings could easily be mistaken for a sculpture.
It connects the two floors and allows natural light from the skylight to penetrate
the lower living area.*

*Beide Etagen sind durch eine skulptural wirkende Stahltreppe mit Glasgeländern
verbunden. So gelangt Tageslicht vom Oberlicht bis in die untere Wohnebene.*

*Les deux étages communiquent par un escalier en acier à l'aspect sculptural, dont
les rampes de verre permettent à la lumière du jour d'illuminer les pièces inférieures.*

# Classical Modernity
## Friedrichshain

IF YOU WERE to fly low over Berlin, this apartment with its large rooftop terrace and striking swimming pool high above the city's rooftops would immediately catch your eye. From the ground, however, you'd never suspect the jewel that lies hidden on the upper floors of the old building in the style of Socialist Classicism. The owner has created a two-floor dream home with four bedrooms, two bathrooms, a guest bathroom, a fireplace room, a kitchen/living room, a rooftop terrace, a sauna, and an outdoor pool. The apartment has a modern, cubical design, with a historic façade facing the street. The furnishings are in the style of the Classical Modernity period. The wall paneling and fittings are made of rosewood and Macassar ebony, combined with marble. Many pieces of furniture are family heirlooms.

WÜRDE MAN IM Tiefflug über Berlin fliegen, dann würde diese Wohnung mit ihrer großen Dachterrasse und dem markanten Swimmingpool über den Dächern der Stadt sofort ins Auge stechen. Von der Erde aus erkennt man dagegen nicht, welch ein Kleinod sich in den oberen Etagen eines Altbaus im Stil des Sozialistischen Klassizismus verbirgt: Über zwei Stockwerke hat sich der Bauherr hier einen Wohntraum mit vier Schlafzimmern, zwei Badezimmern plus Gästebad, Kaminzimmer, Wohnküche, Dachterrasse, Sauna und Außenpool erfüllt. Die Wohnung ist als moderner Kubus errichtet und nimmt zur Straße hin die historische Fassade auf. Leitbild bei der Einrichtung war die Klassische Moderne. Für die Wandverkleidung und Einbauten wurde Palisander- und Makassarholz gewählt und dazu Marmor kombiniert. Viele Möbel stammen aus dem Familienfundus.

SI ON SURVOLAIT Berlin à basse altitude, on remarquerait tout de suite cet appartement avec sa terrasse sur le toit et son imposante piscine. De la terre ferme, on ne se doute par contre pas que ce bijou se dissimule dans les étages supérieurs de cet ancien édifice de style impérial stalinien : le maître des lieux s'est fait construire sur deux étages cet appartement de rêve avec quatre chambres à coucher, trois salles de bains dont une pour les invités, une chambre avec cheminée, une cuisine, une terrasse sur le toit, un sauna et une piscine extérieure. L'appartement a été construit selon la forme d'un cube moderne qui s'approprie la façade côté rue. La décoration rappelle le style de la modernité classique. Les revêtements muraux et meubles encastrés sont composés de bois de palissandre, d'ébène de macassar et de marbre. Beaucoup de meubles proviennent du patrimoine familial.

The fireplace room is decorated in various shades of gray. Much of the furniture, such as the classic pieces by Ray and Charles Eames and Eero Saarinen, are based on designs that date back to the 1950s.

Das Kaminzimmer ist in unterschiedlichen Grautönen gehalten. Viele Möbel wie die Klassiker von Ray und Charles Eames oder Eero Saarinen sind Entwürfe aus den 50ern.

La chambre avec cheminée est dominée par des tons de gris différents. Beaucoup de meubles comme les œuvres classiques de Ray et Charles Eames ou d'Eero Saarinen sont des pièces conçues dans les années 50.

*The kitchen, with its marble countertop, is open to the dining room, which adjoins one of the bedrooms.*

*Die Küche mit einer Arbeitsplatte aus Marmor ist zum Esszimmer hin offen. Daran schließt sich eines der Schlafzimmer an.*

*La cuisine équipée d'un plan de travail en marbre communique avec la salle à manger, qui est attenante à l'une des chambres à coucher.*

*Built in the Bauhaus style, the structure has ceilings that are more than 13 feet high, with windows stretching all the way to the floor. In the summer, family life centers around the rooftop terrace with its fully equipped kitchen.*

*Der Aufbau im Bauhausstil mit seinen mehr als vier Meter hohen Decken ist bis zum Boden verglast. Eine komplett ausgestattete Außenküche macht die Dachterrasse im Sommer zum Zentrum des familiären Lebens.*

*Cette construction de style Bauhaus avec ses hauts plafonds de plus de quatre mètres est recouverte de verre jusqu'au sol. La cuisine extérieure, entièrement équipée, fait de la terrasse sur le toit le centre de la vie familiale en été.*

Classical Modernity | 201

# Courageous Living
## Kreuzberg

ARTIST AND ART director Lizzy Courage lives in her workplace, a 1,700-square-foot loft that used to be a print shop. The floor plan is her own design, and it divides the space into a large living/dining room, a bedroom, and a studio, with a dressing/guest room. She obtains much of her furniture and art objects from artists and designers or purchases them at auctions. The sculptures and ceiling lamps in the living room are Lizzy Courage's own work—provocative art, decorated with collages made of erotic comics, a detail that is not always apparent at first glance. What she likes the best about her home is the unobstructed view through the space. Lizzy Courage may live in the heart of Kreuzberg, but her apartment is a place of tranquility. After all, both sides of her home look out onto backyard gardens.

LIZZY COURAGE LEBT und arbeitet am gleichen Ort, nämlich in einem 161 Quadratmeter großen Loft. Früher befand sich darin eine Druckerei. Den Grundriss durfte die Art-Direktorin und Künstlerin selbst bestimmen. Sie unterteilte die Fläche in ein großes Wohn- und Esszimmer, ein Schlafzimmer, ein Atelier sowie ein Ankleide- und Gästezimmer. Viele Möbel und Objekte stammen von Künstlern und Designern oder aus Versteigerungen. Die Skulpturen und Deckenleuchten im Wohnzimmer sind Werke von Lizzy Courage: provokative Kunstwerke, versehen mit Collagen aus erotischen Comics – was teils erst auf den zweiten Blick erkennbar wird. Was sie an ihren vier Wänden besonders liebt? Die Weitsicht. Auch wenn Lizzy Courage mitten in Kreuzberg lebt, ist es in ihrer Wohnung ruhig. Denn zu beiden Seiten blickt sie auf begrünte Höfe.

CE LOFT DE 161 mètres carrés est le domicile et le lieu de travail de Lizzy Courage, qui abritait à l'époque une imprimerie. La directrice artistique et artiste en a elle-même conçu la mise en plan : un grand salon/salle à manger, une chambre à coucher, un atelier ainsi qu'un dressing/chambre d'amis. Nombreux meubles et objets sont des œuvres d'artistes et de designer ou ont été acquis aux ventes aux enchères. Les sculptures et lustres du salon sont des œuvres de Lizzy Courage ; des œuvres d'art provocantes avec des collages provenant de bandes dessinées érotiques – ce qu'on ne reconnait qu'au deuxième coup d'œil ! Qu'aime-t-elle particulièrement au sein de ses quatre murs ? La clairvoyance. Bien que l'appartement soit situé en plein milieu du Kreuzberg, il est très calme car les deux côtés donnent exclusivement sur des cours intérieures végétalisées.

SWINGER
UNIKAT / N° 12

Lizzy Courage bought her kitchen furnishings from an online auction.
The studio is where she works as an artist and designer.

*Ihre Küche ersteigerte Lizzy Courage im Internet. In ihrem Atelier geht sie ihrer Arbeit als Künstlerin und Designerin nach.*

*Lizzy Courage a acheté sa cuisine sur une vente aux enchères en ligne. Elle pratique son métier d'artiste et de designer dans son atelier.*

Lizzy Courage is an artist who creates unique decoupage objects that tell their own stories. She likes to consult her friend, interior designer Nora von Nordenskjöld, in choosing interior design elements and textiles.

Als Künstlerin schafft Lizzy Courage einzigartige Découpage-Objekte, die individuelle Geschichten erzählen. Bei der Auswahl von Interior-Objekten und Textilien arbeitet sie mit ihrer Freundin, der Innenarchitektin Nora von Nordenskjöld, zusammen.

Lizzy Courage crée des objets d'art par une technique de découpage dont chacun raconte une histoire individuelle. Elle se laisse volontiers conseiller par son amie, l'architecte d'intérieur Nora von Nordenskjöld, quand il s'agit de sélectionner des objets de décoration ou des textiles.

# Index

ARTFUL COLORS
Charlottenburg
Private Property
Gisbert Pöppler Architektur · Interieur
(interior design)
www.gisbertpoeppler.com
Galerie Kornfeld
www.galeriekornfeld.com

BLACK BEAUTY
Mitte
Private Property

FUTURISTIC LIVING
Grunewald
Private Property
Harald Schindele (architecture)
www.hsarchitekten.com

PRIVATE LUXURY
Mitte
Private Property
www.patrick-hellmann.com

ETHNIC TREASURES
Friedrichshain
Private Property
Dreimeta Armin Fischer (interior design)
www.dreimeta.com

TIMELESS ELEGANCE
Charlottenburg
Private Property
www.villa-harteneck.de

MUSIC MEETS MOVEMENT
Charlottenburg
Private Property
Thomas Kröger (architecture)
www.thomaskroeger.net

URBAN OASIS
Kreuzberg
Private Property

COLLECTOR'S PARADISE
Charlottenburg
Private Property
www.frank-leder.com

MIRROR, MIRROR ON THE WALL
Mitte
Private Property
Oskar+Fabian Architecture Studio (architecture)
www.lecarolimited.de

BOHEMIAN CHIC
Mitte
Private Property

LOFT IN KREUZBERG
Kreuzberg
Private Property

BACK IN THE DAYS
Mitte
For rent as temporary residence
Soho House Berlin
Torstraße 1
10119 Berlin
+49 (0)30 40 50 44 — 100
reservations@sohohouseberlin.com
www.sohohouseberlin.com
Nick Jones and Susie Atkinson (interior design)

ROOMS WITH A VIEW
Friedrichshain
Private Property

STYLISH ART LOVERS
Dahlem
Private Property
Gesine Weinmiller (architecture)
www.weinmiller.de
Engel & Völkers AG
Premium Marketing
Stadthausbrücke 5
20355 Hamburg
Phone: +49 (0)40 36 131 374
Fax: +49 (0)40 36 131 448

PRIVATE GALLERY
Mitte
Private Property

COLOR ME SOFTLY
Grunewald
Private Property
cpm ges. v. architekten mbH,
Britt Sylvia Eckelmann
(interior architecture & design)
www.cpm-architekten.de

JOY & JEWELRY
Charlottenburg
Private Property

MODERN GLAMOUR
Wilmersdorf
Private Property
cpm ges. v. architekten mbH,
Britt Sylvia Eckelmann
(interior architecture & design)
www.cpm-architekten.de

CLASSICAL MODERNITY
Friedrichshain
Private Property

COURAGEOUS LIVING
Kreuzberg
Private Property
www.art.lizzycourage.de
Nora von Nordenskjöld (interior architecture)
www.novono.com
Christine Roth (architecture)
www.c-roth.eu

# Biographies

## Stephanie von Pfuel

STEPHANIE VON PFUEL grew up in the Bavarian town of Tüßling, near Altötting. After graduating from high school, she studied forestry and inherited her father's agricultural and forestry business in 1991—along with the family castle. While renovating the castle and outlying buildings, a project that has occupied her for the past 20 years, she discovered a love and passion for decorating and interior design. She published the book "Cool Events at Home" in 2008, followed by "Decorations at Home" in 2011. Stephanie von Pfuel lives in Tüßling, where she organizes trade shows and concerts on her estate. She has six children.

STEPHANIE VON PFUEL wuchs in Tüßling bei Altötting auf. Nach dem Abitur studierte sie Forstwirtschaft und erbte 1991 den land- und forstwirtschaftlichen Betrieb samt heimatlichem Schloss von ihrem Vater. Seit über 20 Jahren renoviert sie das Schloss sowie die umliegenden Gebäude. Dadurch entdeckte sie auch ihre Liebe und Begeisterung für Dekoration und Inneneinrichtung. 2008 veröffentlichte sie ihr Buch „Cool Events at Home" und 2011 „Decorations at Home". Stephanie von Pfuel lebt in Tüßling, wo sie auf ihrem Anwesen Messen und Konzerte veranstaltet, und hat sechs Kinder.

STEPHANIE VON PFUEL a grandi à Tüßling, près d'Altötting. Après son baccalauréat, elle a étudié la sylviculture et a hérité en 1991 de l'exploitation agricole et forestière ainsi que du château natal de son père. Depuis plus de 20 ans, elle s'applique à la rénovation du château et des édifices avoisinants. C'est ainsi qu'elle s'est découverte une passion pour la décoration et l'aménagement d'intérieur. Elle a publié ses ouvrages « Cool Events at Home » en 2008 et « Decorations at Home » en 2011. Mère de six enfants, Stephanie von Pfuel vit à Tüßling où elle organise diverses expositions et concerts dans sa propriété.

## Judith Jenner

JUDITH JENNER BELONGS to a rare breed. She's a genuine Berlin native. Although she loves traveling, when it comes to extended stays abroad, she will abandon her native city only for such pleasant locations as Santiago de Chile or New York. After graduating from Humboldt University with a degree in the humanities, she took a volunteer position with a city magazine. Since then, she has written for a variety of newspapers, magazines, online media, and publishers. Her special interests are architecture, interior design, education, lifestyle, and entertainment—and of course: Berlin.

JUDITH JENNER GEHÖRT einer raren Spezies an: Sie ist echte Berlinerin. Sie reist für ihr Leben gern, tauschte ihre Heimatstadt über längere Zeit aber nur gegen so angenehme Orte wie Santiago de Chile oder New York ein. Nach einem geisteswissenschaftlichen Studium an der Humboldt-Universität volontierte sie bei einem Stadtmagazin und schreibt seitdem für verschiedene Tageszeitungen, Magazine, Online-medien und Verlage. Ihre Themen sind Architektur, Interior Design, Bildung, Lifestyle und Unterhaltung – und natürlich: Berlin.

JUDITH JENNER APPARTIENT à une espèce rare : elle est berlinoise jusqu'au bout des ongles. Elle aime voyager mais n'échangerait sa ville natale pour de longs séjours qu'avec des lieux agréables comme Santiago ou New York. Après des études de lettres à l'Université Humboldt, elle a travaillé comme stagiaire pour un magazine urbain. Elle écrit depuis pour divers journaux quotidiens, magazines, médias en ligne et maisons d'édition. Ses thèmes de prédilections sont l'architecture, le design d'intérieur, l'éducation, l'art de vivre et le divertissement – et bien sûr : Berlin.

# Credits & Imprint

PHOTO CREDITS:

Cover photo by David Burghardt/db-photo.de
Back cover photos by Mark Seelen/courtesy of Soho House, David Burghardt, Christoph Theurer

p 02-03 (Contents)
by NOSHE (top) and David Burghardt (bottom)

pp 04-09 (Introduction)
p 05 and p 06 by David Burghardt; p 09 by Achim Hatzius

pp 10-17 (Artful Colors) p 17 by Gerhard Haug (top), all others by Helenio Barbetta
pp 18-27 (Black Beauty) by Christoph Theurer
pp 28-33 (Futuristic Living) by Carsten Krohn/courtesy of HS Architekten BDA
pp 34-43 (Private Luxury) by David Burghardt
pp 44-55 (Ethnic Treasures) by NOSHE
pp 56-61 (Timeless Elegance) by Marcus Höhn/laif
pp 62-71 (Music Meets Movement) by Thomas Heimann
pp 72-85 (Urban Oasis) by David Burghardt
pp 86-97 (Collector's Paradise) by Achim Hatzius
pp 98-105 (Mirror, Mirror on the Wall) by Gerrit Engel/courtesy of Oskar+Fabian Architecture Studio
pp 106-113 (Bohemian Chic) by David Burghardt
pp 114-121 (Loft in Kreuzberg) by David Burghardt
pp 122-131 (Back in the Days) by Mark Seelen/courtesy of Soho House
pp 132-141 (Rooms with a View) by David Burghardt
pp 142-153 (Stylish Art Lovers) by David Burghardt
pp 154-163 (Private Gallery) by David Burghardt
pp 164-173 (Color Me Softly) by David Burghardt
pp 174-185 (Joy & Jewelry) by David Burghardt
pp 186-191 (Modern Glamour) by David Burghardt
pp 192-201 (Classical Modernity) by David Burghardt
pp 202-213 (Courageous Living) by David Burghardt

p 215 (Biographies) by Mark Krause (Stephanie von Pfuel) and Dirk Dunkelberg (Judith Jenner)

ARTWORK CREDITS:

p 05 by Uwe Tabatt (painting)
pp 12/15 by Tamara Kvesitadze (sculptures)
p 17 by Natela Iankoshvili (paintings in the gallery)
pp 56/60 by Cyril Christo (photographs)
p 59 by Yannick Demmerle (photographs)
pp 76-78 by Uwe Tabatt (paintings)
p 106 by Jacques Olivar (photograph); pp 106/108 by Willem de Rooij (painting); p 109 by Anatoly Shuravlev (photograph); p 110 by Sylvie Blum (photograph); p 112 by Maria and Natalia Petschatnikov (dove installation)
pp 114/116/118-121 by Elliott Erwitt (photographs)
pp 143/145/148/150 by Charles Fréger (photographs); p 144 by Hans Christian Schink (photograph); p 144 by Gerwald Rockenschaub (pink circle installation); pp 145/150/151 by Bettina Bach (pink block sculpture); p 147 by Michael Laube (stripes installation); p 152 by Ólafur Elíasson (skateboard)
p 154 by Hans van Meeuwen (installation); pp 154/156 by Deborah Sengl (sculptures); p 157 by Lies Maculan (installation) and by Tony Conway (mixed media photograph); pp 158/159 by Rainer Fetting (painting)
p 166 by Rainer Fetting (painting); p 172 by Holger Bär (painting)
p 175 by Peter Panyoczki (installation); pp 178/179 by Christo (drawing)

© VG Bild-Kunst, Bonn 2013:
pp 92/93 by Jonathan Meese (painting)
p 112 by Simon Roberts (photograph)
p 144 by Mathieu Mercier (diamond installation)
p 146 by Barbara Probst (photographs)
p 148 by Daniel Rode (neon installation)
pp 154/158-159/162 by Patricia Waller (crochet objects)
pp 164/167/170 by Salomé (painting)
p 176 by Markus Lüpertz (sculpture)
pp 177/180/182/184-185 by Herbert Zangs (mixed media)

Every effort has been made by the publisher to contact holders of copyright to obtain permission to reproduce copyright material. However, if any permissions have been inadvertently overlooked, teNeues Publishing Group will be pleased to make the necessary and reasonable arrangements at the first opportunity.

---

Edited by Stephanie von Pfuel
Texts: Judith Jenner
Translations: WeSwitch Languages, Romina Russo Lais
  English: Heidi Holzer, Romina Russo Lais
  French: Samantha Michaux
Copy Editing: Dr. Simone Bischoff
Editorial Management: Nadine Weinhold
Design, Layout & Prepress: Sophie Franke
Photo Editing: David Burghardt
Imaging: David Burghardt; Tridix, Berlin

Published by teNeues Publishing Group
teNeues Verlag GmbH + Co. KG
Am Selder 37, 47906 Kempen, Germany
Phone: +49 (0)2152 916 0, Fax: +49 (0)2152 916 111
e-mail: books@teneues.de

Press Department: Andrea Rehn
Phone: +49 (0)2152 916 202
e-mail: arehn@teneues.de

teNeues Digital Media GmbH
Kohlfurter Straße 41-43, 10999 Berlin, Germany
Phone: +49 (0)30 700 77 65 0

teNeues Publishing Company
7 West 18th Street, New York, NY 10011, USA
Phone: +1 212 627 9090, Fax: +1 212 627 9511

teNeues Publishing UK Ltd.
12 Ferndene Road, London SE24 0AQ, UK
Phone: +44 (0)20 3542 8997

teNeues France S.A.R.L.
39, rue des Billets, 18250 Henrichemont, France
Phone: +33 (0)2 4826 9348, Fax: +33 (0)1 7072 3482

www.teneues.com

© 2013 teNeues Verlag GmbH + Co. KG, Kempen
ISBN: 978-3-8327-9741-6
Library of Congress Control Number: 2013940493

Printed in the Czech Republic.

Picture and text rights reserved for all countries.
No part of this publication may be reproduced in any manner whatsoever. All rights reserved. While we strive for utmost precision in every detail, we cannot be held responsible for any inaccuracies, neither for any subsequent loss or damage arising. Bibliographic information published by the Deutsche Nationalbibliothek.
The Deutsche Nationalbibliothek lists this publication in the Deutsche Nationalbibliografie; detailed bibliographic data are available in the Internet at http://dnb.d-nb.de.